# LOW TIDE

# LOW TIDE

Jeni Walwin

**Writings on Artists' Collaborations**

# Contents

## Foreword

Inter-disciplinary collaborative practice has emerged as one of the most significant art form developments of recent years. Yet it has received negligible critical attention, a situation compounded perhaps by the apparent temporality of both the work itself and the collaborative partnerships which create it. Thus *Low Tide* has been commissioned by the London Arts Board (LAB) to sift the significance of this collaborative impulse and to document some of its best practice.

This is cunningly mercurial work where art forms merge or collide or metamorphose into something else altogether; where artists experiment with new partners, practices and identities. This is work which offers spectators new ways not just of seeing but of participating. London, in particular, has proved a crucible for collaborative experiment; unsurprising, perhaps, in such a culturally diverse city, home to many artists, rich in different sites, where extremes of wealth and poverty lie uneasily side by side. Needing to respond to and nurture this emergent collaborative trend, in 1992 the Combined Arts Unit of the newly established London Arts Board set up the London Collaborations Fund, inspired by the pioneering New Collaborations Fund of the Arts Council of England. The funding programme quickly established itself as one of the most successful run by the Board, attracting large numbers of applications from artists of astonishing diversity. Through London Collaborations LAB has been privileged to support work demonstrating some of the most important inter-disciplinary trends of the 1990s, including the conjunction of the live and the digital, new approaches to process-based and participatory work and collaborations with disciplines outside the art worlds (especially with science).

The subjects of these essays—Beaconsfield, Bruce Gilchrist and TEA—all received funding from London Collaborations. *Disorders*, curated by Beaconsfield with their customary focus and vision, was an obvious choice for inclusion. This ground-breaking twenty-four hour site-specific event contextualised by its setting in St Thomas' Hospital was created by an excitingly diverse group of artists from different

generations and art practices. It challenged accepted notions concerning both the siting of work and the relationship between artists and audiences in a live context. Bruce Gilchrist has received two research and development grants from London Collaborations for his work with Jonny Bradley. The essay "Subtle Bodies" records the explorations of this extraordinary artist in the realms of art and science. His work demolishes accepted boundaries between artist and audience and creates a spectrum of possibilities for participation. TEA received both a research and development and a production grant for *Mapping Values,* described in this book. The group has pioneered inter-disciplinary collaborative practice of very high quality, particularly through the generation of process-based work which offers powerful possibilities of participation both for non-arts professionals as well as a wider public.

It is a tall order to capture work characterised partly by temporality and evanescence but Jeni Walwin has succeeded. Her precise description and keen analysis, constructed through extensive discussions with the artists provide key insights into the collaborative creative process as well as communicating how the work may have been experienced by spectators, witnesses or participants.

LAB would like to thank Jeni Walwin, all the artists who allowed their work to be documented, Duncan McCorquodale of Black Dog Publishing, and finally the members of the London Collaborations Advisory Group for their wisdom, enthusiasm and support over the past five years.

Paula Brown
Principal Combined Arts Officer
London Arts Board

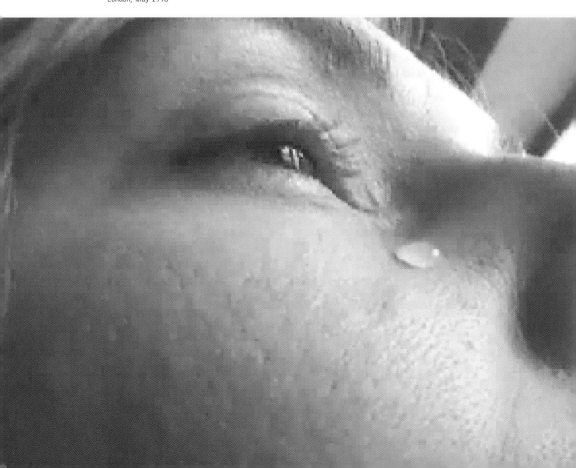

Bruce Gilchrist
Girl Crying from *Mood Centre*
Quick-time video sequence
*Divided by Resistance*
Institute of Contemporary Arts (ICA)
London, May 1996

# Subtle Bodies
## The Work of Bruce Gilchrist

Alone and awake for three consecutive days at his home in Syracuse, Bill Viola allowed the camera to record him sitting, scratching, pacing up and down . . . The result could have been a documentary. Instead—for both viewer and protagonist—it was a study in endurance, exile and altered consciousness. 'Making strange', the Russian theorist Vicktor Shklovski called this technique, proposing it as a prime motive of art. The phrase implies a particular distance between actor and audience, reader and text: a heightened feeling for the grain of wood or the timbre of a voice that can be appreciated only by a diversion from more usual kinds of attention.[1]

It is the concern to create this distance, or rather this nearness, by drawing a spectator into a particular experience, which forms the focus for much of Bruce Gilchrist's recent work. Although developed from a research context that is generated by sophisticated scientific concepts, Gilchrist's performances also function on another, less immediately apparent level which is dependent upon establishing a sensitive physical dialogue between artist and individual audience members.

In May 1996, following an ICA/Toshiba Art and Innovation Award, Gilchrist presented *Divided by Resistance* in the ICA Theatre. Throughout the winter of 1995/96 Gilchrist had made digital electroencephalograph (e.e.g.) recordings of his brain state on waking from REM sleep.[2] His dream reports were categorised and represented by Quick Time video clips. These clips were then associated with the relevant text and e.e.g. files in a database. For the ICA project the artist had reversed his sleep pattern so that the public entered the performance space whilst he was asleep and experiencing periods of high REM activity. Gilchrist's real-time brainwave patterns were monitored and back projected onto a large screen in the rear of the space. A distinctively futuristic atmosphere was produced in the performance environment. This was created by hi-tech machinery, digital imagery, a flashing red light, the sparkling silver hammock, and space-age chair. But amidst the coolness of the technological space there was also the chance of encountering a moment of heightened feeling.

Spectators were able to make choices about the route to the image or sensation which was accessed through a sequence of subtle channels. The most immediately available evidence took the form of video images corresponding to the artist's dream states portrayed on large screens. The sleeping performer's brainwave patterns generated a line of text on the monitors in the foreground of the space. The text then searched the e.e.g. files to find a matching Quick-time video which was then projected onto the screen. During periods of non-REM activity adaptations of colour bar charts appeared. In the days preceding the public performances images were constantly retrieved and overlayed during Gilchrist's sleep periods, yet when the public were finally admitted into the space it was as if the performer presented an automatic barrier to these revelations, even in sleep, and the images emerged more haltingly. Even though the bank of possible images was extensive (there were nearly 300 Quick-time videos in the programme) only a small selection of these were retrieved and re-appeared during the public event, mimicking an obsessional mind state. These tiny clips which only lasted ten seconds reflected our often disjointed recall of dream images. Minute sections of time—for example, one particular action in a performance—were magnified, intensified and given significant status, only to be dispersed and overlayed with a subsequent seemingly

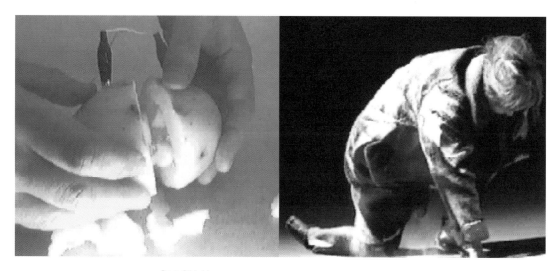

Bruce Gilchrist
Potato from *Potato Electrode* (left)
Flour from *Black Market* (right)
Quick-time video sequences
*Divided by Resistance*
ICA, London, May 1996

unconnected action. Although loaded with narrative quality and interpretive possibility, the close-up, the odd camera angle, and images swelling out beyond the frame overlaid some potentially emotional moments with haunting, formal qualities. For example, the laughing mouth and tear-stained cheek became more than characters in a dream with a part to play, but were somehow transformed for sculptural consideration emphasising surface, sound and texture.

These images were produced on a daily basis over a period of many months. Gilchrist would record his brain state during REM sleep and on waking would summarise his dream memory, creating what he called a "shooting list". In the afternoon of the same day he would visualise the previous night's dream using a combination of images already held on video and shooting new footage. In the process of making these films Gilchrist was concerned to find an appropriate method of translating dream states into conscious, real imagery. He tried to shoot the sequences almost mindlessly, without too much thought or pre-planning. He did to some degree succeed, for even the most figurative, narrative scenes are infused with other qualities, denying the possibility of literal dream-storytelling. The more practiced at recall Gilchrist became, the more material was generated, the more influence this had on shaping future dreams. The seam that was mined so intensely to produce such a rich quantity of images gave only the merest hint of its depth during live performances. The public excavated only the uppermost layer and yet there was a sense that if only we could find the right tools to unearth the fertile seams below, they too would be brought to the surface.

The selection of the dream images was activated by a brief but intense one to one relationship between individual audience participants and the sleeping performer. Each participant was seated in a specially designed chair which incorporated high powered motors corresponding to and supporting sensitive points on the body. These motors were driven by an e.e.g. machine linked to the artist's brainwave patterns. The motor supporting and stimulating the right side of the back responded to alpha (8-14 Hz) frequencies being detected from the right hemisphere of the performer's brain and the audience member's left buttock was supported and stimulated by theta (4-8 Hz) frequencies from the performer's left hemisphere and so on. Whilst experiencing direct physical sensations generated by the artist's brainwave pattern, each participant was given the opportunity of communicating directly with the sleeping performer. The red flashing light indicated that the performer was entering a period of REM sleep and was the signal to invite the audience member to make one question or statement from a prepared list using the tens (transcutaneous electrical neuro-stimulator) unit and a codified language.

This process was dependent upon a highly sophisticated means of electronic communication between one individual and another; yet the physical experience of making that communication and the choice of questions and statements given to the participant subverted the very notion of distance between artist and audience. The participating spectator was physically attached to the performer by a series of wires—reinforcing and yet denying the distance between them. The list of questions and statements from which

Bruce Gilchrist
Installation showing monitors, sleeping performer, participants' chair
and e.e.g. display, *Divided by Resistance*, ICA, London, May 1996
(Photo: Bonie Venture)

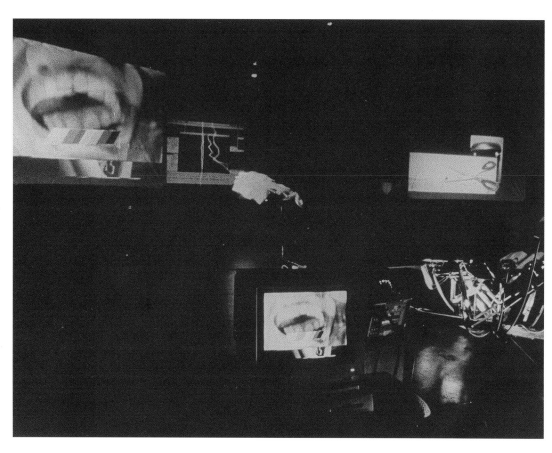

the participant selected a communication with the sleeping performer identified the limitations (and often the impossibility) of verbal communication and the need to search for other more gestural ways of indicating thoughts and feelings, of making oneself understood. It seems appropriate that as Gilchrist is searching for a new language based on code and electrical impulse which might offer a means of communication between the conscious and subconscious minds, he is meanwhile highlighting the inadequacies of current methods of verbal expression.[3]

For those members of the audience not participating in the one to one interaction with the sleeping performer there was a viewing platform raised above the main performance space in which spectators could consider the activity from behind a glazed screen. The atmosphere created in this space carried certain ambiguities. The role of spectator was disrupted by one of voyeur—how could we be sure that those giving electrical stimulus to the performer were following instructions and how far could we allow ourselves to inspect the minutia of someone's dream sleep? But before it was possible to determine exactly what position to take, another emerged. Spectators became scientific witnesses to medical experiment, as if watching the laboratory activity from behind a protective screen. The possibility of surveillance loomed as the roles switched with increasing rapidity. The work is resistant to the fixing of a position. If we are to find pleasure here, then it will be in unexpected places. It will be in that unspecified moment described by David Batchelor in "Living in a material world", when the occurrence is determined neither by art, nor by science, but by a coalescing of the two to create a space which is yet to be authorised.[4]

The opportunity for the spectator to immerse herself in the experience of the event rather than merely to receive and decode a set of visual messages is what sets performance apart from other forms of theatre and object making. It is the ability "to feel the weight of things and one's own place in them", which transforms a spectator into a witness.[5] Artists working in this way invite the audience to feel exactly what it is to be in this place and this time. In his recent performances Gilchrist has developed a more complex set of roles which further extend the notion of 'witness' as engaged participant.

There are potentially three levels on which the witness operates in Gilchrist's work. In the first instance there are the collaborators, who hover somewhere between the role of the artist and that of the spectator. During the last year Gilchrist has worked with transcendental meditators, a tattooist, a writer and a composer in order to pursue his search for physiological and neurological states that might act as material for direct expression. The collaborators are to some extent the equivalent of audience members. Although they create their own sets of images and compositions, they do so within the

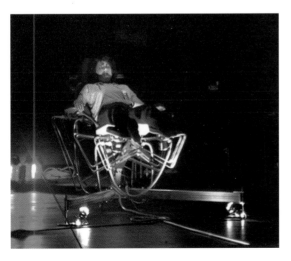

Bruce Gilchrist
Participating
audience member
*Divided by Resistance*
ICA, London, May 1996

15

framework of a Bruce Gilchrist event, allowing their creative process to be inspected by a variety of physical and visual means. They are however more deeply implicated in the work than any other witness since they contribute to and influence the responses of spectators. The collaborators become essential witnesses.

The participating audience members are also witnesses. They experience the vibrations in the clothing or the chair, and in response to the environmental and physical triggers they then make the communication with the artist by activating the tens unit. Having stimulated a visual interpretation of the artist's brain state in reply to this question the participant turns back in on herself and begins to assess what images her own response to such a question might have generated. A moment of reflective thought is grasped amidst the buzz of techno possibility.

The third group of witnesses are those spectators who are drawn into the performance by yet another means. They have not actively participated, they have not creatively contributed, but they have nevertheless been moved by a moment of great intensity, a fleeting instant of bursting emotion. A sense of touch is given lasting visual manifestation, or a few lines of text invoke exotic wanderings in the imagination.

Bruce Gilchrist has occasionally described himself as a predator—a performer who stalks the creativity of others, harnessing artistic potential to a joint project where the ownership of process, emergence of ideas and final image are collaboratively negotiated. It is unclear where the work of each begins and ends. The boundaries between the creative outputs are indistinct, giving a shifting, edgy quality to the performance event which has become a hallmark of Gilchrist's art. The nature of the collaborative process for Gilchrist is unique: it re-routes our experience of the creative act. For each project in which Gilchrist was invited to participate during 1996 he selected collaborators who were pertinent to the context in which the programme was presented. For *Transmutations*, which was part of Art of '96 at the Zap Club in Brighton, Gilchrist was commissioned to devise a performance on the theme of alchemy and transmutation. This provided a perfect opportunity to use the Galvanic Skin Response (GSR) activated clothing as it transmuted one form of experience into another. The clothing operated much in the way that the chair did for *Divided by Resistance*, except that it translated the electrical skin events (rather than the brainwave patterns) from the bodies of the performer and the tattooist to the wearer.

Gilchrist contacted a local tattooist, Ian Lester, and presented him with a computer-scan of his left thumb-print, to be transferred onto the artist's right arm and tattooed. Both artist and tattooist were connected to a Galvanic Skin Response machine by electrodes on their skin, and when physical contact was made via the tattooing needle, the electrical circuit was closed producing a sound signal. This sound fluctuated in response to the changing electrical skin resistance. As well as being processed and amplified, the signal was split into the GSR jacket and shoes enabling solitary members of the audience to experience a tactile manifestation of the image, in the form of the vibrating electric motors.[6]

Bruce Gilchrist
*Black and Decker Light Bulb*
Quick-time video sequence
*Divided by Resistance*
ICA, London, May 1996

The physical process of creating a lasting visual image on the surface of the body is translated into sound within the space, and touch within the spectator's clothing. Artists have for many years been concerned with making visible the process of creativity. By focussing on their ability to transform rather than to produce, it is no longer necessary for them to be makers of things. In this performance Gilchrist makes connections between people, activities and their surroundings, transmuting a painful physical process into a sound environment and energised clothing.

The decision to collaborate with Gilchrist on one of his projects is not one taken lightly. It is usually necessary for collaborating artists to feel mutually sympathetic towards the artistic objectives of the work. But in the context of Gilchrist's activities they must also be prepared to work with electronic equipment with which they may be unfamiliar, and

to reveal aspects of their thought processes and subconscious for public inspection. It is interesting to ascertain what effects these very special circumstances of production have on the creative process.

Nick Rogers, a writer, was invited to participate in *Art Emergent/Dissident States* which was commissioned by Beaconsfield for the Disorders project at St Thomas' Hospital in August 1996. He visited Gilchrist's studio for several weeks preceding the performance. Each time he was connected to an e.e.g. machine and asked to think about his unwritten book. The brainwave patterns that resulted from this thought were recorded onto the hard disk of a computer. Periodically a mild electrical stimulus was administered as a cue for Rogers to write down his recollected thought immediately prior to the stimulus. These texts were then linked to their concurrent brainwave patterns to form an extensive database. During the performance Rogers again thought about his unwritten book whilst his brain states were monitored in real-time. The brainwave patterns triggered spoken text. The electronic speech was accompanied by graphic representations of the e.e.g. patterns which were projected onto the wall in the darkened space. The writer's real time brain states were also driving a series of small vibrating electric motors embedded in a rubber jacket and shoes. Fluctuations in the e.e.g. pattern were represented by the ebb and flow of vibrations within the clothing. Spectators were invited to wear the tactile clothing while listening to the stories and viewing the graphics.

Throughout his involvement in this project Nick Rogers was encouraged to speed up the process of thinking, creating and writing. During the course of the project he produced ideas more quickly than he has ever done before, but he was not able to consider them and refine them with such attention to detail that he might have achieved in other

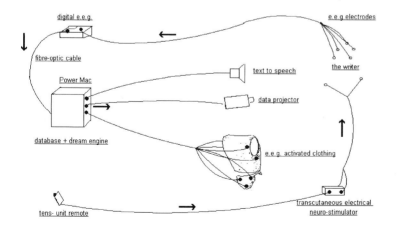

digital e.e.g.

e.e.g electrodes

fibre-optic cable

Power Mac

text to speech

the writer

data projector

database + dream engine

e.e.g. activated clothing

tens- unit remote

transcutaneous electrical
neuro-stimulator

Bruce Gilchrist
Schematic Drawing
*Art Emergent / Dissident States*
for the *Disorders* project
at St Thomas' Hospital
London, August 1996

circumstances. His ability to produce fluid data in his first sessions in Gilchrist's studio was hampered by a nervousness about working with such a revealing process. Much of the early text was therefore slow in emerging and often repetitive. A similar nervousness gripped him when he began 'performing' at St Thomas' Hospital. These thought processes were therefore matched with the earlier texts in the database. As the twenty-four hour time span of the project progressed so the emerging texts became more fluid:

Johnson and Page sashayed into the cavernous tavern.

"Why", asked Page, fingering the stem of her glass of brandy,

"do you seek the living amongst the dead?".

"That's a good question, that", replied Johnson.

Come on.

I am a pen and you—you are my hero.

Not you.

Him.[7]

The experience that Nick Rogers described after taking part in this project seemed in many ways to reflect the creative process itself—in that moments of insight, of artistic vision are by necessity preceded by moments of hesitation, indecision, turmoil and confusion. The further investigation of the creative process, and the possibility of inter-cepting "nascent thoughts—the building blocks of ideas—at the moment they emerge into the conscious realm, and giving them concrete form" is the basis of the research project currently being undertaken in collaboration with Jonny Bradley.[8] A wide cross section of the public will contribute to the research. E.e.g. recordings will be made of creative activity—sculpture, drawing and object making using a range of media. Each object will be documented on video from a number of perspectives during its making. These photographic video images will be time coded so that they can be matched with e.e.g. patterns and create a new database. The material will then be incorporated into live art events where members of the audience will create objects generated by their mind state using the data collected during the research period.

The collaboration with composer and jazz pianist Nikki Yeoh on *Thought Conductor* represented a shift in the relationship between Gilchrist and the public event. This was a *Piano Circus* programme seen over three days at the Place Theatre in November 1996. Nikki Yeoh had been invited to write a new piece for six pianos to be premiered at this event. Bruce Gilchrist's intervention on this occasion was as an integral part of someone else's project. Prior to the performance Nikki Yeoh had worked with Jonny Bradley to create a software programme which translated her thought processes into musical notation.[9] During the performance she was connected to a digital e.e.g. machine and asked to attain a concentrated state and to think through the musical score of *Six as 1*, her recent commission. Her live e.e.g. data was then translated directly through Jonny Bradley's Dream Engine software and midi control into musical notation trans-

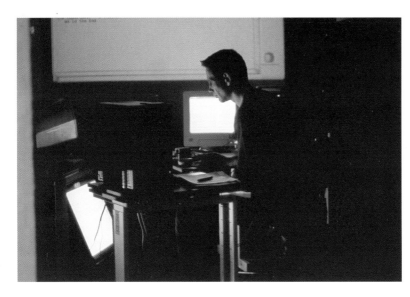

mitted via computer monitors positioned on each of the six pianos. Each area of her thought process related to a monitor on a different piano—the top right piano responded to the alpha rhythms in her brainwave pattern and so on. The e.e.g. data also controlled the behaviour of Jo Joelson's digital light curtains—the lighting conditions were cued by changes in brainwave frequency.

Of all the projects discussed here this was the one in which the visualisation of thought transference was most apparent. The methodology was perfectly exposed, the process of thought transformed into music was live and immediate, and a new language was grasped. It was as if the brainwave patterns had been unpicked and laid out at each of six strategic points within the space awaiting the pianists' response. This process of laying bare achieved what Gray Watson has described as the "cool" pole of performance where the principle interest lies in the work's exploration of formal and structural issues.[10] Bradley and Gilchrist have researched and systematised a language which no longer depends on a database through which the e.e.g. recordings have to search for matching files. They have established for the hard disk a set of musical codes which will interpret brainwave patterns live onto monitors. Successful and impressive though this may be, the experience for the spectator remains one of distance and cool detachment. By comparison to other Gilchrist performances there is less opportunity for spectators to become witnesses, and to position themselves within the work. For Gilchrist's work in general the engagement with issues and process is a vital component and a necessary influence on the relationship between performer and audience.

For *The Discarnate* project which was presented as part of the *Phenomenal* season at the Centre for Contemporary Arts in Glasgow, Gilchrist negotiated a collaboration with an auric healer and a deep meditator who practiced astral projection. His brief to both contributors was to attempt to induce out of body experiences during their public

presentations. The meditators were connected to digital e.e.g., their brain states monitored in real time and back projected onto a screen. They were also attached to a Galvanic Skin Response machine and their skin activity activated motors in the special clothing worn by members of the public who entered the space one at a time. Whilst in the clothing, the participant directly faced the meditator in trance, experienced the ebb and flow of vibrations in the clothing, considered the fluctuations in the brainwave pattern, and was encouraged to make assumptions about the relationship between their states of mind.

During the two hour sessions the meditators experienced a great variety of trance states, ranging from dream sleep to moments of intense awareness, from problem solving reverie to instants when time stops. From the video documentation of the project it is apparent that they must have experienced moments of altered consciousness when the alpha, beta and delta rhythms in the brain were balanced and the back projected images of their brainwave pattern showed symmetrical alignments on both sides creating a shape like a compressed diamond. This configuration indicating a resourceful state is known as hemispheric synchronisation. Participating members of the public also reported feelings of deep relaxation, and sometimes experiencing such a strong response that they would find connections even when they didn't exist.

For Peter Harper, one of the meditators, this collaboration was a particularly positive experience. He feels that Gilchrist's performances give visible manifestation to much of his own research into ways of stimulating creativity and meditation. He also suggests that the potential for giving visual awareness to altered states could be ultimately significant in proposing alternatives to chemically induced experiences. Furthermore the parameters for the practice and appreciation of art are also extended out of the collaboration with transcendental practitioners. Over the three days of *The Discarnate* project Gilchrist worked with the mediums for a time during each morning and then put himself to sleep for the performances in the afternoon, giving spectators the opportunity to encounter one or other meditator during the first session of the day

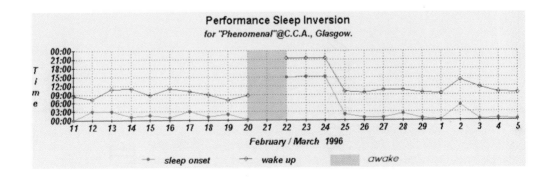

21

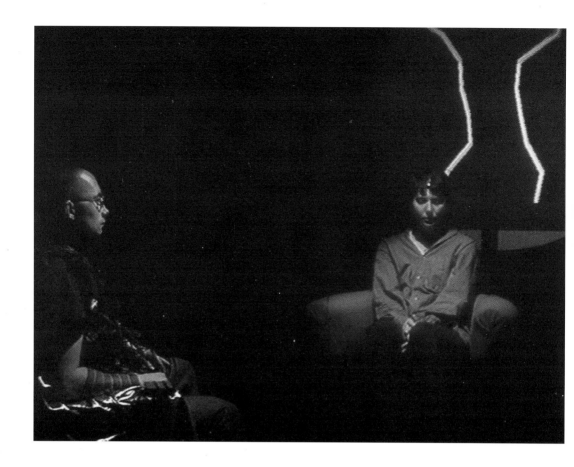

and himself during the second. Using this approach Gilchrist established the possibility of interchanging roles between performer and spectator, artist and medium and demonstrated that all are capable both of seeing and showing, and of being seen.

In this project, in *Divided by Resistance* and in *Transmutations* Gilchrist pursues the role of both victim (exposed, whilst often in a vulnerable state of sleep or pain, to the button-happy members of the audience) and of perpetrator (who has established the context and parameters for the work and who prescribes the setting for the audience participants). Such irony underlies the significance of each work and these shifting, contradictory positions are similarly transferred to the spectators. How vulnerable can we really be if we are imbued with certain powers over the performer, but how prepared are we to exploit that domination if we are not confident about the consequences of the actions involved? In some degree influenced by the ambiguity of their role in the event, and by the possibility of unravelling the unconscious, spectators experience an equivalent sense of exposure, alternating between victims and assailants, uncertain about their final position.

Exploring the fabric of our unconscious is a particular concern for many British artists. Chrissie Iles points out that automatic writing, infantile speech and primal utterances have been used to create a space for otherwise silent, marginal voices. Artists working in performance have been especially adept at giving space to these marginal voices. Gilchrist's use of codified, electrical languages creates the same possibility of a communication with the subconscious as do Brian Catling's rich and raw cries into the deep. Catling sets up the expectation of discovering magic in art, in order to demonstrate its failure and hint at the richness of what lies beyond. Gilchrist proposes the visual and sensual representation of the subconscious as performance icons, but immediately denies that possibility by drawing attention away from the visual and into direct physical exchange.

> I must become a warrior of self-consciousness and move my body to move my mind to move the words to move my mouth to spin the spur of the moment. (*Site Recite: a prologue*). The idea is not to follow and track down the mundane body, but to have it undergo a ceremony which affects both sounds and gestures, making the body a grotesque from which there then emerges a gracious body. [11]

Gilchrist pursues the notion of ceremony to such an extreme during his performances that it is not always easy to retrieve the gracious body. We are aware of altered states of sleep, of the possibility of uncovering despair in the subconscious. We are uncertain about making the journey into the scientifically unknown. It is hard to find the subtle channels of access. There are two possible responses to this. We may feel alienated by the technology and daunted by the possibility of crisis which we refuse to acknowledge, or we may on the other hand see in the work a reflection of our own impossibility

(opposite)
**Bruce Gilchrist**
Composite image showing
audience member, meditator
and e.e.g. display
*The Discarnate*
Centre for Contemporary
Arts Glasgow, February 1996
(Photograph courtesy of Right
and Left Video Productions)

(right)
**Bruce Gilchrist**
Schematic Drawing
*Transmutations* for
the Art of '96 Season
at the Zap Club
Brighton, March 1996

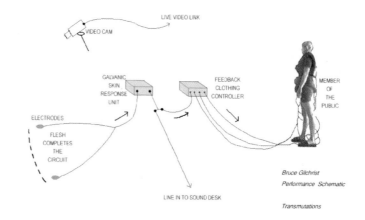

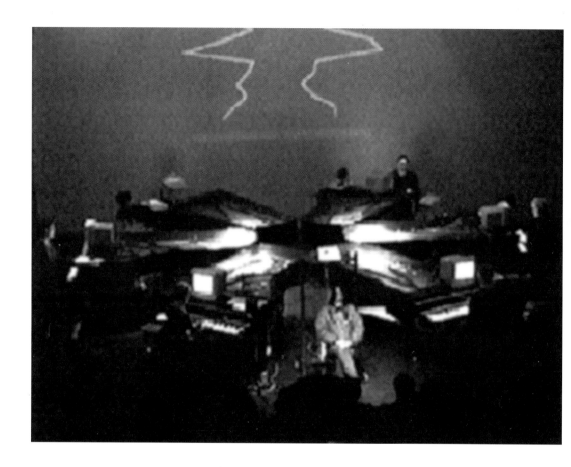

and in so doing understand something of what is meant by 'making strange' and move a little way towards a perception of what was hitherto unknown or unseen.

In these performances the boundaries between science and art, between art and life, between the conscious and subconscious minds have become blurred. It is not always clear what position we are expected to occupy in relation to the work. But it is this uncertainty about boundaries and categories which gives the work its existence, which empowers and offers potential rather than entraps and defines. We cannot content ourselves with merely being present at one of Bruce Gilchrist's performances, we must enter the space prepared to identify our responses and open ourselves up to the experience of doing so.

Bruce Gilchrist
Piano Circus performance showing six pianos,
pianists, monitors, composer Nikki Yeoh in
the foreground and an e.e.g. display derived
from her thought processes in the background
*Thought Conductor*
The Place Theatre, London, November 1996

# Notes

1. Morgan, Stuart, *Rites of Passage*, London: Tate Gallery Publications, 1995.

2. REM = rapid eye movement. Research has demonstrated that most vivid dreaming occurs during REM sleep. It is characterised by an active brain, with low amplitude mixed frequency brain waves, suppression of skeletal muscle tone, bursts of rapid eye movements, and occasional tiny muscular twitches.

3. Audience members were asked to chose one question or statement from the following:

   1) What is the place of gesture in communication?  x   x   x   x   x   ----   x   ----

   2) Can you respond to this question?  x   x   ----   x   x   ----

   3) Ne Plus Ultra?  x   x   ----

   4) I'm not certain what I'm interfacing with.  x   x   ----   x   x   ----   x

   5) Haven't we met somewhere before?  ----   x   x   ----   ----

   6) How can I disrupt the boundary between inside and outside?  x   x   x   ----   x   ----   ----   ----   x   ----

   7) I love you.  ----   ----   ----

   8) Am I in danger of being misunderstood?  x   x   x   ----   x   x   ----

   9) There is something about the way people move in space that aids communication.

   x   x   ----   x   x   x   ----   x   x   x   x   x   ----

   *Using the symbols (x) and (----) which referred to short and long bursts respectively, audience members were able to communicate with the sleeping performer using the tens unit.*

4. Batchelor, David, 'Living in a Material World', *frieze*, Issue 35, 1997

5. Etchells, Tim, introductory essay, *A Split Second of Paradise*, London, Rivers Oram, November 1997.

6. The descriptions of all the performances have been taken from notes written by the artist or from conversations between him and the author during 1996 and 1997.

7. Extract from texts produced by Nick Rogers for the database.

8. Taken from notes written by the artist.

9. Jonny Bradley is one of Bruce Gilchrist's most significant collaborators. He is currently working on TV and multi-media projects for Automatic Television and has a particular interest in the development of synthetic neural-networks and radical human-computer interfaces. With Gilchrist he established the databases for all of the projects discussed here.

10. Watson, Gray 'Performance Art: a Contextual and Historical Overview' in *Live Art Now* London: The Arts Council, 1987.

11. Diserens, Corinne, 'Time in the Body', in *Gary Hill* ex. cat., Oxford: Museum of Modern Art, 1993.

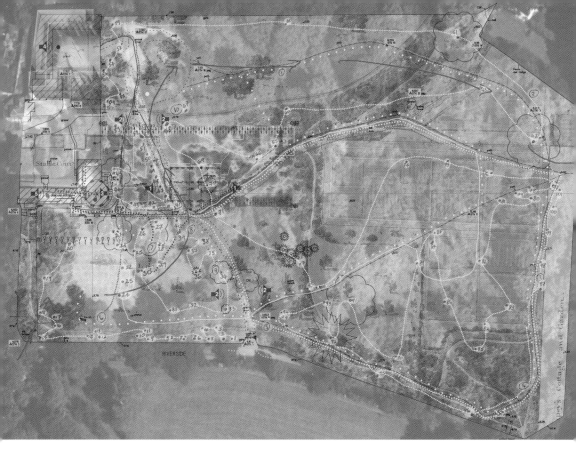

**TEA**
Map showing evidence gathered
and surveys undertaken
(detail from the Guide)
*Mapping Values*
Orleans House Gallery and Gardens
Twickenham, July-August 1997

**Between Here and Now**
The Work of TEA
(Those Environmental Artists)

Ritual has largely been abandoned within contemporary British culture. Religion and its pagan precedents no longer provide a central focus for community life. With the demise of spiritual beliefs as a galvanising force within society the rituals developed to express those beliefs have disappeared. But what has been lost is more than the ceremonies themselves. Rituals usually invoked something special for the participants beyond what was actually visible—indicating spiritual, visionary or unseen magical experiences beneath the surface of the actions. In order to restore the balance in our lives in a highly industrialised rational world we need to find a way of rediscovering 'the divine'. Suzi Gablik proposed that the 1990s should become an era in which the word 'ecological' might become the equivalent of the word 'metaphysical'. She advocated that this decade might witness the re-establishment of the spiritual within our culture, and that in order for this to be achieved it would be necessary to restore awareness of our relationship with nature.[1]

Over the last ten years the work of TEA (Those Environmental Artists) has encouraged a re-viewing of the places, spaces, sites and locations in which we live, work and pursue leisure activities. TEA's projects have generated a new interest in our environment in general and in the way we develop our individual relationships to it in particular. Alongside the ecological imperative TEA also propose a poetic one—a means by which those of us who are not artists, but who encounter the work as ordinary members of the public, can discover a poetic possibility, a vision of something hitherto unseen or unknown, in our response to a familiar object or well known place. A third and critical aspect of TEA's practice is developed out of the tension between art as a platform for individual genius or as a genuine means of embracing contributions from a wider public in the name of art. TEA have successfully established a position for marginal voices and have given visibility to the passer-by and to a range of practitioners and professionals working outside the confines of the art world but whose responses to a site or time help shape our appreciation of it.

We seek to enter and involve systems outside the art world in order to contribute to the expansion of the boundaries traditionally associated with an art practice, and often perceived to be alienating by the general public.[2]

TEA offer an unique approach to art making and one in which the spectator will often have an active and influential part to play. TEA are four sculptors (Peter Hatton, Val Murray, Lynn Pilling and Jon Biddulph) who maintain their individual practices and have worked together since 1987. The notion of creating isolated art objects for passive appreciation plays no part in TEA's work. Their projects offer a new means of engaging with a public, giving a range of different people an opportunity of becoming participants in the work. TEA have been particularly successful in reaching many who have not been involved in art before and who in this process have bequeathed new identities and status to familiar objects, periods in history, and sites of architectural and historical interest.

Coincidental with the proposing of new strategies for the appreciation of and involvement in contemporary art practice, elements of TEA's work also make reference to earlier twentieth century movements. They devise methodologies for art making which refer back in time and create possibilities for dreaming our future. The link to Mass Observation is a case in point. In the work of both TEA and Mass Observation a dialogue is established between official, published archives and personal memories.

Mass Observation was established in the 1930s by Charles Madge and Tom Harrison who recognised the gap between the views of 'ordinary people' and those published in the papers and on the radio as public opinion. Mass Observation was to be a Nation-wide Intelligence Service which would bridge this gap and give voice to the 'nobodies'. Tom Harrison had been an anthropologist in Borneo and on his return to the UK decided he wanted to pursue his fieldwork in his own country. Victor Gollanz sponsored the establishment of Harrison's headquarters in Bolton in 1936. Charles Madge, the co-founder, was a journalist and poet and although he was based in London, together with Harrison they encouraged many artists, writers, intellectuals and photographers to contribute to the Bolton project—making recordings, gathering data, taking photographs, collecting evidence of daily life in the industrial heartland of Northern England. Many of those who became associated with Mass Observation were also Surrealists (Humphrey Jennings, David Gascoigne, Stuart Legg, and Kathleen Raine) and they were drawn to it because of the chance to investigate "how contemporary public opinion interacted with widely held phobias and desires".[3] From a Surrealist and Freudian point of view public and political images were seen to have an unconscious psychological dimension.

In their 1994 project *Anxiety and Escapism* TEA were commissioned by the South Bank Centre, London, to create an exhibition which took a new look at the 1930s. The decade is often considered to be the most mythologised period of the twentieth century and TEA were interested to discover how information on that time has entered into folk memory. Their approach was in some way indebted to Mass Observation—"a complex

28

TEA
exhibition installation
*Anxiety and Escapism*
Royal Festival Hall
London, 1994
(Photo: Paul Grundy)

# LEISURE

(both images)
**TEA**
Visitors contributions
*Anxiety and Escapism*
Royal Festival Hall
London, 1994

of contemporary forces: populism, statistical social surveys, surrealism, naive realism, anthropology, investigative reportage and documentary impulses".[4] The *Anxiety and Escapism* project comprised survey, installation and archive. TEA researched and reproduced original documents from the 1930s. Newspaper cuttings and recorded sound were then used as official backdrops in the exhibition space. At the core of the project were the personal commentaries compiled during the course of the exhibition and suspended in transparent plastic folders creating a see-through maze within the space.

It was at that point that the distinctions in approach between TEA and Mass Observation became apparent. In their attempts to give voice to the 'nobodies' the Mass Observation artists nevertheless remained in control of the image making throughout—much as an extension of the colonial experience which many of the artistic contributors had undergone. The observer remained at a distance from the observed. Fact was accorded Surrealist status. Many found, social objects uncovered by Mass Observation surveys were transformed into Surrealist *objets trouvés*—the photograph by Julian Trevelyan in 1937 of the mobile tea van shaped liked a giant teapot was considered to be a good example of British Surrealism. The process of ascribing poetic quality to such images was deemed possible only by the intervention of the artist who, in emphasising the gap between the viewer and the subject, merely served to reinforce it. By maintaining the distance between artist and subject the potential to threaten or disturb was minimised. All positions were secured and the possibility of resistance was denied.

TEA on the other hand have created opportunities for exchanging positions between artist and spectator, between the observer and the observed. In this exhibition and in the subsequent archive document they have given voice to personal reminiscence, created space for individual opinion, and promoted gossip as evidence of comic historical narration. 2,272 questionnaires were completed by members of the public and displayed in the installation at the Royal Festival Hall. Contributions were made to each of three sections on work, home and leisure. The questions explored the ways in which we absorb information and determined what status we accord it depending on whether it was received from official sources such as newspapers, radio recordings, photographs in magazines, or from personal sources such as family albums or recollections of older friends and relatives.

It was apparent from these contributions that the poetic qualities ascribed to much of Mass Observation's documentary material were as evident in the 1990s as they had been sixty years earlier, except that this time they were not originated by practising artists but by visitors to the exhibition. In response to the question "What is your impression of Home in the 1930s?" one reply was as follows:

Dark wood,
Dark lino,
Dark gravy,
Dark goings-on

All contributions were anonymous and taken together gave no unified picture of the period. The University of Lancaster has made an academic analysis of the information and found that in the Home section for example, contributions were split almost equally between those who saw it as a golden age and those for whom it was probably the grimmest moment of the century.

Evident in much of TEA's practice is the pursuit of an alternative to the documentary. After the war documentary photography became a fashionable means of retelling a factual story. By the 1970s galleries and magazines were devoted to the form. The images themselves were subsequently recruited for more specific political ends. In an attempt to minimise the gap between the observer and observed, documentary film soon followed and large tracts of television time were, and still are, devoted to "telling us how it is". The scale of the distribution which necessarily accompanies the presentation of these images is vast—so many millions watch the television programme, so many more see the photographs in books, magazines and newspapers—and yet the ability for individuals to influence those stories or contribute to the image making is limited.

TEA create systems for making their work which offer exactly that opportunity. For the project *Other People's Shoes* on which TEA collaborated with Impossible Theatre, a number of strategies were developed which generated evidence on the history of shoe design and production, on distribution and retailing, on myth and on personal image-

building. Contributions to all these issues were elicited from factory workers, retail salespeople, visitors to the exhibitions and participants in the community workshop programme. These contributions represented the essence of the project and created documentary evidence about individual personalities derived from the investigation of the role of an everyday object—something which we all have a relationship with. Whether shoes were seen as protection or as a fashion item which displayed the character of the wearer, or whether they were seen as witness to our lives in our treatment of them, the response was overwhelming. Over two years in three regions (Lancashire, the East Midlands and Yorkshire) members of the public designed and had made for them their ideal shoe, and for each exhibition they selected or donated shoes with accompanying personal histories.

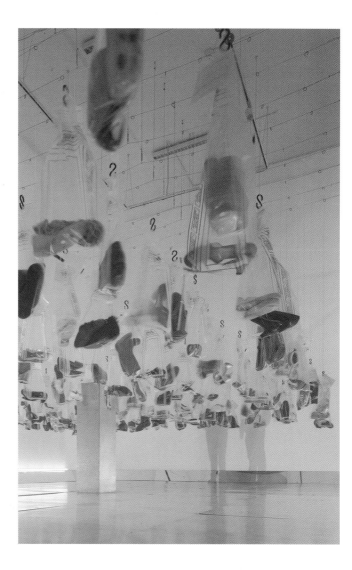

**TEA/IT**
Museum Installation
*Other People's Shoes*
Leeds Metropolitan
University Gallery, 1994
(Photo: Paul Grundy)

In response to evidence given by the public, the artists created one-off hand-crafted designs and machine-tooled shoes during factory residencies. TEA then established retail outlets where they worked as sales assistants. In these specially created 'shops' the concepts for the perfect shoe were displayed alongside the shoes made during the residencies and other shoes commissioned from artists in response to an open submission. Artists were given an open brief to create shoes as art works and in some cases specific concepts were commissioned from specialist footwear makers, for example to make a piece of historical footwear.

For each exhibition those living locally, those who had participated in the workshops and those who had contributed to the project so far were invited to donate or select a pair of shoes which would be submitted for display with an accompanying story about the reason they had been chosen—these ranged from descriptions of experiences whilst wearing them, to favourite shapes and colours which held special associations. During the museum installations the artists were involved in classifying, logging, displaying and seeking the narratives amongst the donated and selected shoes and their informative labels. The exhibitions were dominated by rows and rows of suspended plastic bags containing shoes and their labels recording the personal history. The bags and their contents were lit from below creating a ghost-like, macabre quality which reinforced the lack of human presence in a space where individual stories still resonated. The shoes became poignant symbols of all that their owners had invested in them. By contrast the performances, which also took place in the gallery, wove a humourous narrative between the lifeless objects, improvising the characters who might have worn them. In many ways *Other People's Shoes* set out as an archaeological exercise to uncover evidence of the wearer. Once that had been achieved the material underwent further transformation and produced evocative characteristics as the basis for installation and performance.

An archaeological approach is also apparent in TEA's examination of the gallery and grounds at Orleans House, Twickenham. *Mapping Values* drew on many archaeologies, both contemporary and historical, professional and anecdotal, to reveal a range of sensitive appreciations of the site. Orleans House and gardens was the focus for a research project which involved past owners, relevant professionals, regular visitors and walkers in the uncovering of its multi-layered history. The project developed over three years and embraced contributions from local history groups, a geophysical surveyor, planning strategists and aboriculturalists to name but a few. As with most TEA practice, the process of gathering the information from those groups and individuals, and the time spent observing the site was as much an equal part of the project as the production of the final evidence. The resulting images, soundscapes, maps, surveys, personal anecdotes and diagrams were presented to the visitor in three ways. The printed guide was constructed from the research and acted as a record of it. It included a map of the site indicating points of particular interest and it documented contributions from a wide cross section of individuals. Inside the gallery the *Mapping Values* archive was

accessed via CD-ROM and offered the possibility of another journey through the project and around the site. The sound installation, on which Kate Tierney collaborated with TEA, linked the indoor and outdoor experience of the work, layering present-day sounds of the site with personal memories of its history.

> The first time I discovered Orleans House was when I was at school, and it was the last day. Everyone came out of the classrooms and through a little gap in the fence at the back. For me it was associated with release and leaving an era behind.
> —Rachel Mulligan.

> There are several pipestrelles buzzing around so the sounds are getting more complicated . . . there's a noctule still feeding out over Ham House. It's remarkable how all these different bats are out here and you can't see them.
> —John and Jane Tovey, and Margaret Bunce (members of the West London Bat Group) 24 June 1996.[5]

In their ability to synthesise daily experiences with visual and recorded data, in their success at drawing on skills from a range of non-art disciplines, and in their dexterity in moving backwards and forwards through personal and published history, TEA offer the possibility of blurring, and in some instances eliminating, the boundaries between art and life. By synthesising disparate elements, the categories distinguishing them are no longer relevant and this process is often associated with the merging of art and non-art.[6] In this sense TEA's work represents an accretion of Wagner's concept of *Gesamtkunstwerk* (total work of art) which he perceived as a site for the intersection of all art forms. To achieve an artistic goal which followed in the tradition of the Bauhaus, Duchamp, Beuys, etc., was perhaps never TEA's intention, but it has nevertheless come about as a direct result of each project's determination to uncover a means of involving the spectator in the image making, drawing evidence from a range of contributors, and in so doing offering a new channel of access to the work.

**TEA**
Andrew Fletcher
conducting Land Survey
*Mapping Values*
Orleans House Gallery and Gardens
Twickenham, July-August 1997

**TEA**
Mark Noel undertaking
geophysical survey
*Mapping Values*
Orleans House Gallery and Gardens
Twickenham, July-August 1997

**TEA**
Andy Pinder conducting Tree Survey
and Peter Hatton recording
*Mapping Values*
Orleans House Gallery and Gardens
Twickenham, July-August 1997

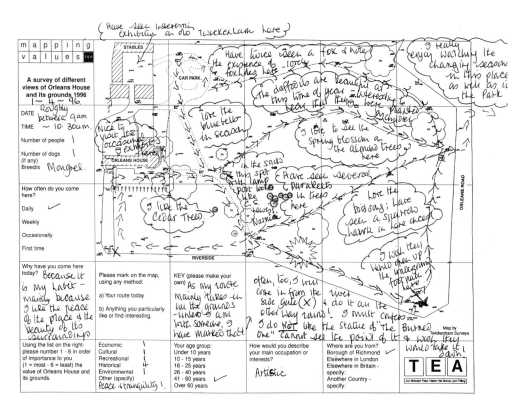

mapping values **TEA**

STABLES
CAR PARK
ORLEANS HOUSE
RIVERSIDE
ORLEANS ROAD

**A survey of different views of Orleans House and its grounds 1996**

DATE Roughly 1-4-96.

TIME between 9am ~ 10.30a.m.

Number of people 1

Number of dogs 1
(if any)
Breed/s Mongrel.

How often do you come here?

Daily ✓
Weekly
Occasionally
First time

Why have you come here today? Because it is my habit - mainly because I like the peace of the place & the beauty of its surroundings

Please mark on the map, using any method:
a) Your route today
b) Anything you particularly like or find interesting.

| | |
|---|---|
| Economic | |
| Cultural | 1 |
| Recreational | 1 |
| Historical | 4 |
| Environmental | |
| Other (specify) | 1 |
| Peace & tranquility. | 1 |

Using the list on the right - please number 1 - 6 in order of importance to you (1 = most - 6 = least) the value of Orleans House and its grounds.

KEY (please make your own) As my route Mainly takes in all the grounds - unless I am with someone, I have marked that

Your age group:
Under 10 years
10 - 15 years
16 - 25 years
26 - 40 years
41 - 60 years ✓
Over 60 years

How would you describe your main occupation or interests? Artistic

Where are you from?
Borough of Richmond
Elsewhere in London
Elsewhere in Britain - specify:
Another Country - specify:

Handwritten map notes:
( Have seen interesting exhibitions on old Twickenham here )
I really enjoy watching the changing seasons in this place as well as in the Park
Have twice seen a fox & note the existence of foxholes here
The daffodils are beautiful at this time of year - interesting to hear they were planted by children
I love the bluebells in season
I love to see the spring blossom on the almond trees here
Have seen several parakeets in trees here
Love the birdsong; have seen a sparrow hawk in here once
In this spot with lamp post looks like C.S. Lewis's "Narnia"
I like the Cedar Trees
I wish they would open up the underground footpath here
often, too, I will come in from the river side gate (X) & do it all the other way round. I must confess I do NOT like the statue of "The Burned one" cannot see the point of it & wish they would take it down

Map by Twickenham Surveys
Jon Biddulph Peter Hatton Val Murray Lynn Pilling

**TEA**

Site Visitors' Map
*Mapping Values*
Orleans House Gallery and Gardens
Twickenham, July-August 1997

**TEA**

Extracts from Commentaries
(detail from the Guide)
*Mapping Values*
Orleans House Gallery and Gardens
Twickenham, July-August 1997

Peter Strachan
Artist
26th March 1996

"Slowly, slowly it became a gallery. There were concerts, music, activities and it drew the people of Richmond and Twickenham into it, but in a very slow gentle kind of way. There have been such good things here I feel it's got a huge future."

Shoes outside the Gallery
Photo : Peter Strachan

Mark Noel
Geophysicist
25th/26th Oct 1995

"It appears that we've got some correlation between the geophysical readings and where the central part of the building is. I'm quite hopeful that we're finding rubble, demolition rubble associated with old Orleans House."

Detail of Geophysical Survey
GeoQuest Associates

Mavis Batey
Garden History. Soc.
1st April 1996

"What was fine taste later on in the 18th century was very much the natural style of garden so a lot of the formality was taken away. We could perhaps evoke the Orleans House period when Louis Philippe lived here by having a little bit more of the Regency planting."

King Louis Philippe visiting Orleans House in 1844
E Pringret. © L.B.R.U.T.

**TEA**
Four Seasons from the Octagon
*Mapping Values*
Orleans House Gallery and Gardens
Twickenham, July-August 1997

37

*Looking Both Ways,* in 1995, proposed further encounters between art and non-art worlds. TEA were invited to make an installation at The Tate Gallery, Liverpool, and they proposed an investigation of The Royal Liver Building situated close to the Gallery and visible from one of its spaces. The Chairperson of Royal Liver Insurance agreed to assist with the project. Employees from the twenty four tenant companies and the nine contractors were sent questionnaires on a picture postcard of the building asking about the spaces in which they worked and the effect the building had on them. From these replies individuals were selected for more in-depth descriptions of their work spaces. These were subsequently played back over telephones in the gallery space, which also contained the postcard replies from the office workers, light boxes showing interior details of the building, and diagrams and drawings of its internal, rarely visible, work-ings. The life of this significant landmark building was turned inside out—its fleshy insides revealed to gallery visitors. The exposure of its internal workings acted as the springboard for a further questionnaire targeted particularly at the gallery visitors. In receiving an ongoing body of evidence, the installation remained 'live' throughout its four month duration. At this point, the project also developed another dimension, crucially marking the moment at which TEA's work becomes more than simply a collection of archaeological or documentary evidence. The information gathering gave visitors the opportunity to establish their own narratives for The Royal Liver Building, but it also acted as an inspiration for the completion of the second questionnaire eliciting imaginative personal responses to spaces and places in which people lived and worked or where dreams were dreamt and memories conjured.

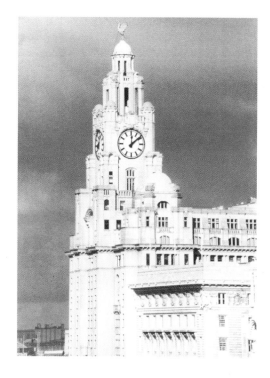

TEA
Royal Liver Building
*Looking Both Ways*
Tate Gallery
Liverpool, 1995
(Photo: TEA + Tom Wood)

38

The archive produced following the closure of the exhibition is testament to these poetic contributions. In a section of the second questionnaire, members of the public were asked to draw or write about a particular building or part of one which mattered to them personally. Within just a small sample of responses the variety of interpretations and depth of personal interest in answer to this question was impressive. One contributor described the building, now demolished, where she and many members of her family had been born, another drew an image of a building which had first appeared in a dream and was subsequently discovered in a remote country road as if the dream had come to life, another described in minute detail the inside of their hamster's cage, and another drew and described the block of flats she could see from her living room window, urging that they be pulled down and the residents given the opportunity of living in what she described as "proper houses".

The replies on postcards from which these examples are taken operate like tiny fragments of contemporary history. But unlike some traditional views of history, these documents are not fixed or predictable. They raise more questions about a moment in time than they are able to offer answers. They nudge forward the debate on environment, on issues of personal and public space, and most importantly they become tiny anonymous works of art whose status and value is uncertain. Even the archiving of this material is approached with TEA's inevitable inventiveness. Rather than be housed in one spot, gathering dust and obscurity, the postcards are divided up and dispersed once again.

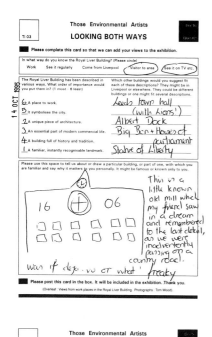

## Card 1 (top left)

Please complete this card so that we can add your views to the exhibition.

In what way do you know the Royal Liver Building? (Please circle)
Work   See it regularly   Come from Liverpool   (Visitor to area)   See it on TV etc.

*14 OCT 1995*

The Royal Liver Building has been described in various ways. What order of importance would you put them in? (1 most - 6 least)

Which other buildings would you suggest fit each of these descriptions? They might be in Liverpool or elsewhere. They could be different buildings or one might fit several descriptions.

6 A place to work.
5 It symbolises the city.
2 A unique piece of architecture.
3 An essential part of modern commercial life.
4 A building full of history and tradition.
1 A familiar, instantly recognisable landmark.

Leeds town hall (with Lions')
Albert Dock
Big Ben + Houses of parliament
Statue of Liberty

Please use this space to tell us about or draw a particular building, or part of one, with which you are familiar and say why it matters to you personally. It might be famous or known only to you.

16 ⊕ 06

This is a little known old mill which my friend saw in a dream and remembered to the last detail, as we were inadvertently passing on a country road.

Was it deja-vu or what? freaky

Please post this card in the box. It will be included in the exhibition. Thank you.
(Overleaf : Views from work places in the Royal Liver Building. Photographs : Tom Wood)

## Card 2 (top right)

Please complete this card so that we can add your views to the exhibition.

In what way do you know the Royal Liver Building? (Please circle)
Work   See it regularly   Come from Liverpool   (Visitor to area)   See it on TV etc.

*14 OCT 1995*

The Royal Liver Building has been described in various ways. What order of importance would you put them in? (1 most - 6 least)

Which other buildings would you suggest fit each of these descriptions? They might be in Liverpool or elsewhere. They could be different buildings or one might fit several descriptions.

5 A place to work.
1 It symbolises the city.
3 A unique piece of architecture.
6 An essential part of modern commercial life.
4 A building full of history and tradition.
2 A familiar, instantly recognisable landmark.

Houses of Parliament.

Please use this space to tell us about or draw a particular building, or part of one, with which you are familiar and say why it matters to you personally. It might be famous or known only to you.

← The block of flats I can see from my living room. It matters to me because I would like it knocked down + people to live in proper houses.

Please post this card in the box. It will be included in the exhibition. Thank you.
(Overleaf : Views from work places in the Royal Liver Building. Photographs : Tom Wood)

## Card 3 (bottom left)

Please complete this card so that we can add your views to the exhibition.

In what way do you know the Royal Liver Building? (Please circle)
Work   (See it regularly)   Come from Liverpool   Visitor to area   See it on TV etc.

*26 AUG 1995*

The Royal Liver Building has been described in various ways. What order of importance would you put them in? (1 most - 6 least)

Which other buildings would you suggest fit each of these descriptions? They might be in Liverpool or elsewhere. They could be different buildings or one might fit several descriptions.

5 A place to work.
1 It symbolises the city.
3 A unique piece of architecture.
6 An essential part of modern commercial life.
4 A building full of history and tradition.
2 A familiar, instantly recognisable landmark.

India Buildings
St Georges Hall
'pl Museum
Mersey Tunnel
Town Hall
Albert Dock

Please use this space to tell us about or draw a particular building, or part of one, with which you are familiar and say why it matters to you personally. It might be famous or known only to you.

I will miss Oxford Maternity Hospital because my sister & I where born there also my husband and my two children. Every time we drove passed we always used to say "I was born there and dad and you and you and we would burst out laughing it became an old family joke but now its gone!!

Please post this card in the box. It will be included in the exhibition. Thank you.
(Overleaf : Views from work places in the Royal Liver Building. Photographs : Tom Wood)

## Card 4 (bottom right)

Please complete this card so that we can add your views to the exhibition.

In what way do you know the Royal Liver Building? (Please circle)
Work   (See it regularly)   Come from Liverpool   Visitor to area   See it on TV etc.

*14 OCT 1995*

The Royal Liver Building has been described in various ways. What order of importance would you put them in? (1 most - 6 least)

Which other buildings would you suggest fit each of these descriptions? They might be in Liverpool or elsewhere. They could be different buildings or one might fit several descriptions.

6 A place to work.
1 It symbolises the city.
1 A unique piece of architecture.
1 An essential part of modern commercial life.
1 A building full of history and tradition.
6 A familiar, instantly recognisable landmark.

LIBRARIES
ST. GEORGES.
ALTHAM ROBERTS B[...]
TRAIN ST.
L'POOL MUSEUM
BIG BEN

Please use this space to tell us about or draw a particular building, or part of one, with which you are familiar and say why it matters to you personally. It might be famous or known only to you.

my wendy house is speshel to me because I Bilt it in my garden

Please post this card in the box. It will be included in the exhibition. Thank you.
(Overleaf : Views from work places in the Royal Liver Building. Photographs : Tom Wood)

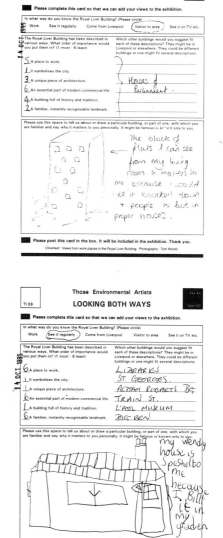

**TEA**

Responses to Questionnaires

*Looking Both Ways*

Tate Gallery

Liverpool, August-October 1995

Rather than lodge these rich documents in an archive or make a selection for a publication we have decided to preserve the potency of the individual encounter by distributing the originals to people we hope will be interested in being their keepers.

We are enclosing your unique fragment of the Looking Both Ways archive. If you do not wish to keep it please could you return it to us or pass it to someone who would like to be a keeper? If you do this could we ask you to let us have a note of their name and address for our records? [7]

In many of their projects TEA have begun to map out the potential for establishing new rituals appropriate to the disparate set of cultural references from which contemporary society draws its strength. TEA allow for personal intervention and individual creativity, across a range of subjects and practices, amateurs and professionals. There are no exclusion zones. All individuals can contribute to life's renewal if they sufficiently believe that they can. Yet finding the appropriate channels to do so is an altogether more challenging task. Jean Francois Lyotard has observed that "artists are pushed forward, they are literally chased out of the very deconstructed forms they produce, they are compelled to keep on finding something else". The creative momentum replaces ritual in artists' lives. They continually search for hidden meaning and produce works which they hope have special resonance beyond that which is visible. For those of us who are not artists, the opportunity to encounter the work of TEA is a valuable one. They will leave doors open for us and will give us every encouragement to contribute to the transforming process, offering on the way a glimpse of a ritual which could become personally significant.

## Notes

1.  Gablik, Suzi, *The Reenchantment of Art*, London: Thames and Hudson, 1991, pp. 42-52.

2.  Extract from a letter written by TEA to *Artists Newsletter*, November 1995.

3.  Mellor, David Alan, "Mass Observation: The Intellectual Climate", *The Camerawork Essays*, London: Rivers Oram, 1997, pp. 133-142.

4.  Mellor, "Observation", pp. 133-142.

5.  Extracts from *Mapping Values* guide.

6.  Batchelor, David, *Minimalism*, London: Tate Gallery, 1997, pp. 64 & 65.

7.  Extract from letter sent to all recipients of a section of the archive. Similar letters and fragments were distributed following the *Anxiety and Escapism* project.

Sarah Cole
*Playing with Fire*
actions, CCTV Monitor
*Disorders*
St Thomas' Hospital
London, August 1996
(Photo above: Jon Byers)
(Photo below: Nic Percy)

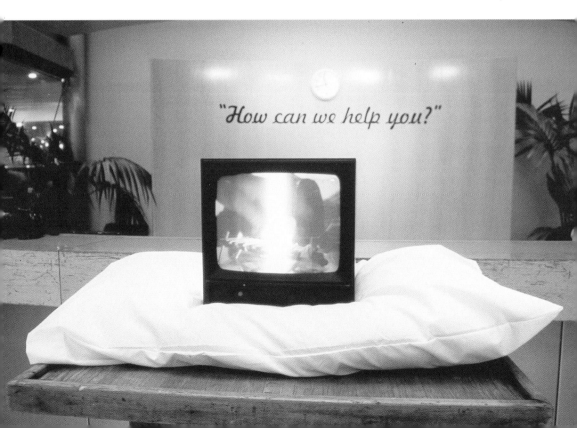

## Disorders
A Twenty-Four Hour Event
Curated by Nosepaint and
Produced by Beaconsfield for
St Thomas' Hospital, London

Suzi Gablik has proposed that culture must take back its aliveness, its possibility and its magic. Modernism demanded that in order to retain its critical edge, art must be difficult. Yet it is now possible for art to embody modes of relatedness and to follow a conceptual shift (which is also taking place in science) away from objects and into partnerships. Modernism's fundamental role was confrontation and its aesthetic depended upon ego and alienation. The context in which art was made and presented was irrelevant. However, in some of the most influential art practice of the 1990's context has been returned to the heart of the work. It is not just the site of the commission or the physical placing of the work that is of significance (although these considerations are relevant to the *Disorders* project) but more critical to the impact of such practice is the way in which artists themselves have given their art a framework against which it can be viewed. This is a quite different approach to that used either by the community arts movement of the 1970's where process achieved new status and the cultural and political context of that process was paramount. Nor is it the same context as that taken up by issue-based art, when for example Stephen Willats became an artist-in-residence on a London housing estate and produced a number of politically specific works highlighting his experience.

These new frameworks are much more personally driven. Although they reflect universal imperatives such as fear, loss, hope, death, desire and fantasy, they are often triggered by autobiographical experience or involve a particular personal obsession. Neither the issues the work raises nor its methodology can be generalised, but there are perhaps two recurring characteristics of such work. Firstly, there is the work which explores the territory between the public and private domains, investigating collective fears and fantasies. In Gillian Wearing's film and photoworks for example the ironic and multi-layered images have broad interest, creating possibilities for a number of interpretations and weaving often complex relationships between the artist, the viewer and

the subjects themselves. Secondly there are the works which are often the result of a previous action or intervention by the artist—almost like the end product of a performance. The resonance of Cornelia Parker's work for example, is heightened by the understanding of its archaeology - indeed knowledge of each work's history is a necessary part of its appreciation. A silver teapot, twisted in shape and marked by dashes of white powder is of purely formal interest until the engraved text reveals the date on which it was hurled over the White Cliffs of Dover along with several other pieces of Victoriana. These were retrieved from the beach below and for an exhibition in Germany subsequently suspended in a line which followed the exact configuration of the cliffs from which they had been thrown.

The creation of an inspiring context is therefore not entirely dependent on an enlightened curator. Artists have taken that initiative themselves. Nevertheless Beaconsfield (as the curators and producers of this project) have created a poignant context in which a number of artists have been invited to make work. Beaconsfield had originally been developing ideas for a 24 hour project entitled *Gout* which they hoped to site at St Thomas' Hospital. A number of artists had been approached to make work on the theme of life cycles. After some initial discussions with the hospital it then transpired that Guy's and St Thomas' Trust was considering ways in which attention might be drawn to the opening of a new Sleep Centre and the two initiatives were brought together. The Sleep Centre at St Thomas' is responsible for the research, diagnosis and treatment of the full range of sleep disorders and is the first of its kind in the UK. It offers a full multi-disciplinary approach to treating sleep disorders involving neurologists, psychiatrists, ear nose and throat specialists and clinical psychologists. The centre can treat 200 people each year and if necessary a patient's sleep can be monitored in the bedroom/laboratories using highly trained technologists to perform a range of tests measuring brainwave and muscle tone activity, eye movements, heartrate and rhythm, breathing patterns and oxygen levels.

The Beaconsfield project then changed its name to *Disorders*, the briefs to artists shifted from a reflection on mortality towards sleep in particular, and a summer date for the event was agreed. The curators have always acknowledged that working in public spaces often requires compromise and re-working of initial plans—this project was no exception. Beaconsfield were keen that the performances and installations should stretch from dawn to dawn over the period of one day. Hospitals function around the clock each day of the year and Beaconsfield's timetable would reflect this constant activity. Artists were invited to make work that spanned the twenty-four hour duration, which could accommodate passing interest from anyone using the hospital (medical staff, patients and visitors), and which reflected in some way the issue of sleep. Many of the thirteen artists invited to take part in this project were already well known to Beaconsfield or had worked with them before. Each was selected because of their ability to create a new performance or installation which would have resonance within the hospital context and which would implicitly or explicitly respond to the notion of sleep.

Beaconsfield confirmed with the hospital authorities a number of sites both inside and outside the building which could be used for this event. Artists then visited and selected an appropriate location. Each was made aware of others' contributions through artists' meetings at which individual projects were outlined. In their selection of artists Beaconsfield had identified an interesting combination of well established names and recent graduates, of those who make large scale outdoor work and those who might use aspects of the interior structure of the building to create smaller, more intimate pieces.

For some artists the creation of a work for a particular site resulted in an installation which ran continuously for the twenty-four hours, but which did not require the artist to be present. Early on in the project Michael Klega, a Czech artist currently working in London, had proposed a number of ambitious sculptural possibilities which would have required the building of walls and installing of a number of fragile elements within them. His final contribution was by comparison simple but effective. The electronic

Matthias Jackisch
*How to Draw*, Installation and Performance
*Disorders*, St Thomas' Hospital, London
August 1996  (Photo: Nic Percy)

45

display board leading from the main cafe into the lift lobby announced the titles given by Sigmund Freud to the dreams which form the basis for his analysis in *The Interpretation of Dreams*. The impact which this project made was quickly announced by the fact that within minutes of the display board being turned on the press office at the hospital received an enquiry about the Pope's health. One of Freud's dream titles reads "Pope is Dead". This was the first element of the *Disorders* project which I encountered and it seemed to provide a fitting introduction to the event—a silent, strong work evoking history and place and drawing the frame of reference around the conscious and unconscious mind, between wakefulness and sleep. These fifty titles, although created by Freud who has so much influenced our attitude to the subconscious, re-presented here in Klega's context, also offered the chance for quiet, personal consideration of what those phrases might mean in other circumstances—"Dissecting my own pelvis", "Glass top-hat", "Running upstairs undressed", "Castle by the Sea".

With the dream titles left behind, the spectator finds herself in the corridor on the way to the lift lobby. Beaconsfield selected an existing work for this site. Guillaume Paris' video *Minding* was especially pertinent. The cartoon character of an owl, whose body moved forward and circled in frantic haste whilst its head remained motionless, hinted at the possibility of speeding endlessly towards what we perceive to be our goal and yet remaining stationary or at least feeling that we make no progress. It brought to mind the phrase once coined by Jenny Holzer, "At times inactivity is preferable to mindless functioning". The constant mirroring of the spectator's gaze by the owl produces an unnerving tension between anxiety and amusement. Although surrounded by all the comic associations of cartoon characters, this creature, returning the gaze so intently, creates something of a hypnotic state in the viewer which is at once absorbing and disturbing. Beaconsfield had particularly chosen to site this work in a waiting area,

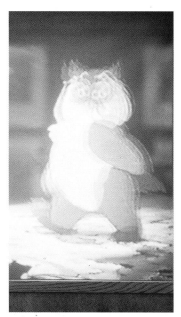

**Guillaume Paris**
*Minding*
Video installation
*Disorders*
St Thomas' Hospital
London, August 1996
(Photo: Jon Byers)

46

remarking on the tendency for things to spin round and round in your head whilst waiting, waiting, waiting—an experience reflected in the owl's twirling motion.

David Cunningham installed a soundwork in all four lifts which leave the main lobby and travel the six storeys of the hospital. Intermixed tapes of insects and birdsong from a diversity of environments created an ambiguous, artificial soundscape. The sound levels varied so that if for example the lift was full of chattering hospital workers there may have been no recognition of the sound piece until either the sound levels increased on the tape or the conversations subsided. Many interpretations of the archaeology of the sounds were offered - could they be from a tropical rain forest, or perhaps from a stretch of Cornish moorland? That neither was true (because the tape had been woven together using many different recordings) was not the issue— more that the audience had been transported by a series of sound associations from the real site in the moving metal cage to a more exotic spot in their imaginings. This piece was part of a series of ongoing installations created by Cunningham in which the physical presence of the spectator acts as both witness and contributor to the sound environment. Cunningham describes his work as sculpture—in that there is a consistent structure moderated by the conditions of the space in which it exists. The spectator in this instance is the moderator of the space.

The second soundwork in the *Disorders* project was once again presented with delicate ambiguity. Beaconsfield installed a soundtape in a cupboard at the far end of an unusually quiet corridor. This piece, the Paris video and Sonia Zelic's film, which was reworked for the medical context, were the only works not commissioned especially for the hospital, but they were equally successful because of their careful integration into the situation. Muffled knocking noises, wind blowing and metallic vibrations hinted at a disturbing narrative from a Victorian gothic novel—spirits of times past somehow locked into the fabric of the building. In other ways the piece was disarmingly formal, overlaying uncertain sounds one upon another much in the way that the hospital has transformed itself from Victorian institution into a hi-tec medical service for the next century.

A candy coloured clown they call the sandman
Tiptoes to my room every night
Just to sprinkle stardust and to whisper
"Go to sleep everything is alright"

*In Dreams*
Roy Orbison

John Carson was briefed to offer a wandering presence in the hospital corridors making a physical link between one artist's project and another. The resulting work, with snippets from dreams and songs of sleep, acted as a framing device for the entire event.

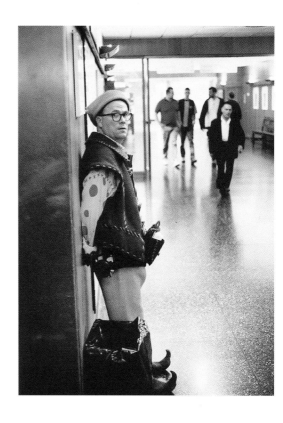

John Carson
*Performance*
*Disorders*
St Thomas' Hospital
London, August 1996
(Photo: Nic Percy)

Carson's role was initially conceived as an interactive one—he carried a microphone and tiny speakers on his belt—but in the event this aspect of the performance became problematic. People felt awkward and unwilling to enter into conversations about sleep and dreaming with someone who was so obviously (indicated by his Sandman costume) a performer. The hospital had anticipated the public's reluctance to participate in this event—signalling the need for privacy and unobtrusiveness when making work for patients or their visitors. In order to accommodate the circumstances as they evolved, Carson resolved to develop the wandering minstrel character without audience participation. Sometimes he would slow down and hover like a strolling player close to groups of people, and occasionally in a more crowded public space he would perform from a fixed point like a talking statue so that spectators could experience a range of material. His recitals were taken from popular songs and descriptions of individual dreams. Carson's performance work has often derived from popular culture (images, soundtracks, and well-known songs). Each is carefully selected and edited and then returns in a new context to tell a different story. For *Disorders* he became a subversive master of ceremonies who determined not to make the announcements but nevertheless became a roving reminder of all the issues which this fascinating project revealed and created a parallel story alongside the day's events.

Not surprisingly several artists chose to focus on the image of the bed, used for sleeping, dreaming and convalescing (all central themes of this project) and so often the place of birth, sex and death. Whilst being associated with the restorative powers of rest and sleep, the bed is also the place where violent desire is played out, where nightmares are dreamed and where we fear surrendering to our unconscious. For Rona Lee the bed had already become a significant image in her work and the invitation to take part in this project gave her a chance to develop the motif with even greater intensity.

On visiting the hospital I was struck by the series of ceramic Doulton murals (made exactly 100 years ago in 1896) which line the main corridor. Significantly, nursery rhymes and fairy stories alike, often feature sleep or the nocturnal world as motifs. In the bedtime ritual of storytelling the part played by such tales resonates powerfully in connection to sleep disorders—the moment before falling to sleep being one of particular psychic and physical vulnerability. The image of a bed is in itself a potent one, the site of various primary experiences death, birth, sex, it may represent a much sought after place of rest and peace, but also carries with it the possibility of loss of conscious control, fear of which manifests itself in nightmares, insomnia, fear of the dark and so on. It relates to existing interests within my work in the capacity of the known and familiar to become disturbing—that which Freud termed the uncanny.[2]

During the course of the twenty-four hours Lee performed six actions in the exit to the Shepherd Hall Dining Room. Onto a bramble covered bed she projected an image of the release from slumber of Sleeping Beauty, immediately drawing images from the hospital itself into her action. She then wove a bandage around the empty bed-frame giving the object a persona and highlighting the interrelationships between carers and the cared for. As she completed the weaving so the projection of the Sleeping Beauty image became more precise and the representation of the physically demanding and repetitive role of the carer was replaced by one of dream and childhood fantasy. During her third action tacks were used to pin dried rosebuds onto a crisp white sheet creating a forlorn sense of loss. These delicate flower fragments held in place by sharp pointed metal tacks became symbols of both violence and vulnerability and, finally viewed on the suspended sheet, evoked a number of conflicting sensations—memorials to absent loved ones or bitter memories of anxious experiences.

Lee's next event was an intense and physically demanding action lasting two and a half hours. She kissed the entire surface of the clean white sheet with a molasses solution, leaving sweet imprints of her lips pervading the tiny space. The fifth action continued the nursery rhyme theme inspired by the murals nearby. This time the bed was draped with a luxurious black velvet coverlet onto which snippets from well-known rhymes were written with a bleach filled syringe. There was a momentary time lapse between the writing in bleach and the visible emergence of the text, giving the sense of an almost magical process to one which was grounded in the destructive qualities of bleach. For the final action enormous stones were laid in a rectilinear shape at the foot of the bed. The artist carried the stones in the fold of a white night shirt she was

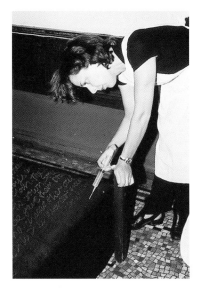

(left)
**Rona Lee**
*installation/performance*
*(Action 4)*
*Disorders*
St Thomas' Hospital
London, August 1996
(Photo: Jon Byers)

(both images opposite)
**Kirsty Alexander
and Paul Burwell**
A twenty-four hour performance
with several parts
*Disorders*
St Thomas' Hospital
London, August 1996
(Photo: Jon Byers)

wearing and placed them carefully on the bed. Lee's actions became increasingly demanding as the day progressed. As something of a climax to the physical endurance of the previous hours, she then dug out a small niche in the stones and deprived herself of other senses by putting on a blindfold and earplugs and settled into the stone hollow in a sleep-like state.

Throughout Lee's work there has been evidence of recurring themes - the relationships between love and destruction, between nurture and violence, and of the disturbing within the domestic. For Freud the domestic space was the first space of the uncanny. It was the place in which objects had a propensity to turn on their owners and the fairy stories here offer "the perfect vehicle for exploring the uncanny within the reassuringly domestic".[3] Many of Lee's repetitive physical actions have their root in domestic routine - stitching, heating, bandaging, ironing—but as she transforms them for her performances she gives these actions a certain ambiguity. She becomes both mother and child, creator and destroyer. The rosebuds are pierced by sharp tacks, the nursery rhymes are revealed through a negative stain on the velvet—violence underlies apparently delicate and caring behaviour. Even after the performance has ended when we are confronted by the objects in Lee's absence, there is a clear trace of her action which has given new meaning to these familiar items.

Kirsty Alexander and Paul Burwell developed a number of works in outdoor sites which although not incorporating an actual bed made several references to sleep and tracked the passing of time. They presented a sequence of sculptural danceworks involving three performers. One of the most striking images in this sequence was created when Kirsty Alexander was strapped inside a stretcher and pinned vertically to the stone pillar outside the cafe. Renaissance church stone carvings, Florence Nightingale with her lamp, and the delicate balance which we all tread between physical fitness and ill

health were mingled together in the interpretations of this piece. Many of these sequences made reference to time clocks. The figures swinging in hammocks suspended between the branches of two trees whose levels were adjusted by large weights attached to the ropes created a giant pendulum which swung up and down and from side to side producing a melancholic sense of the inevitability of passing time. One of Alexander and Burwell's final presentations took place on the fire escape leading to an inner courtyard of the hospital. The dancers performed beneath a curtain of water whilst weaving their way up and down the twirling stairway reminiscent (like the stretcher piece) of the history of public sculpture—this time the putti in the fountains—and yet at the same time hinting at the healing qualities of water and spas associated with restoring health.

Many of the issues raised by Sarah Cole's work for "Disorders" reflected those that emerged from Rona Lee's—the powerful symbol of the bed, the interplay of child and adult roles, the contrasting depictions of innocence and destruction—yet the resulting work, although equally poignant, brought forward a different set of actions and images. There were four elements in this work, "Playing with Fire", which were enacted without interruption throughout the twenty four hour period. In a tiny lobby (ironically this was the fire exit on the north side of the building) minute hospital beds were constructed using matchsticks. At intervals of approximately fifteen minutes these tiny beds were set alight and their remains were sealed into small polythene bags which were then displayed

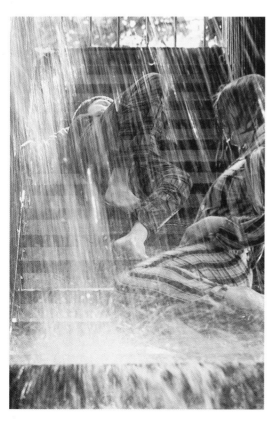
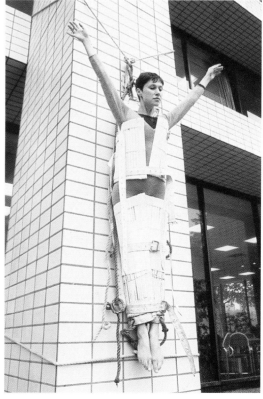

on the window of the lobby. A CCTV camera filmed the burning of the beds and the image was relayed in real-time to a tiny monitor nestling on a clean white pillow perched in the centre of the hospital's main reception desk. The position of the monitor mirrored the position of a person's head upon the pillow—the relayed image on the screen could therefore be seen as a dream, a nightmare or a form of night terror, witnessed by the viewer, but possibly experienced by any individual in or out of hospital.

Whilst the childlike occupation of the bed-building had some reminiscence of toy model kit constructions and was in its way both intricate and humourous, the closed circuit image of the beds on fire was enormously disturbing—particularly because of the way in which the action was framed against a busy hospital walkway. The scale of the bed on the monitor became distorted, enlarged and life size. If, as I did, the spectator encountered the monitor without having first seen the activities in the lobby (which was some way distant and out of sight of the monitor), then what appeared on the screen was akin to terrorist activity—we imagine we are witnessing some violent action in a public space where passers by (whose heads are cut off by the screen) are hurrying on. Imagine the relief when, later, you eventually discover the site of the filmed action and the actual size and fate of these burning beds is revealed. The charred remains of each

Anne Bean
*Peace in Rest*, performance and projection
*Disorders*, St Thomas' Hospital, London, August 1996
(Photo: Robin Chapika)

bed carefully displayed in regimental lines across the windows are resonant of war graves, or perhaps specimens in forensic science—they lend a sombre note to the work, they give it its twist. What began as a light-hearted plaything for children ended as burnt out remains. The surveillance equipment is fundamental to the distancing of the action, and to the ambiguous interpretations which are necessarily placed upon this work. Neither the performance nor the image on the monitor, nor the final manipulated objects are at the centre of this work but each weaves a relationship with the other to create a new meaning for the first and out of which the strength of Cole's work emerges.

Anne Bean's piece also incorporated a number of elements—performance, printing, projections, drumming and dance. Whereas Sarah Cole's work involved construction and destruction of sculpture to form a body of evidence, Bean's built up over the twenty-four hours, transforming a circular garden in the hospital grounds into a vast sculptural clock. The performance began with bright blue handprints printed onto thermal paper and laid at the mark of each minute of the clock face on the minute every hour for twelve hours. By 11PM the hand prints had reached the outer limits of the lawn, creating a visual record of the entire duration of the project to that point. Its expansion reflected a number of other timetables in the hospital's vicinity, for example medical staff shifts and visiting hours. As the sculpture evolved it became more clearly visible from a range of vantage points within the hospital itself, and several members of staff responded to the work and discussed its development with the artist. Between 11PM and midnight the performance became more intense. Directly across the River Thames from the site of this work is a nationally significant icon—the geographical relationship between Anne Bean's 'clock' and Big Ben were marked by an imprint of the artist's face in sugar projected from the St Thomas' sculpture onto the south face of Big Ben. Dancers produced blue body prints onto thermal paper laid at the outer limits of the sculpture. At the tip of the circle, marking each ten minute sequence in the clock face, bright white buckets with glass tops lit from inside formed the receptacle for the artist's headprints to be made in sugar at five minute intervals. In the outer ring of the garden clock Paul Burwell drummed in the water following the exact track of the hand of Big Ben around the dial between 11PM and midnight. As the clock struck twelve so the sculpture in the hospital garden was complete. The projection of Bean's facial imprint was replaced by a second image of a revolving globe projected immediately below Big Ben's dial between midnight and 6AM when the *Disorders* event closed.

The success of Bean's work has always sprung from her ability to conceive events and performances which have enormous visual impact coupled with an intricate and sensitive interpretation of the given context. "Peace in Rest" is no exception. She has produced a work which takes full advantage of both the site, context and location. The sculpture is produced from a series of images taken from fragments of the body, eventually creating a unified and celebratory work which might reflect both the working methods and the aspirations of those employed in the hospital. The deeply contorted image of the artist's own face projected onto a key government building hinted at the need for personal

commitment to partnership and the bringing together (as this image literally does) of seemingly separate strands of thought towards a common goal.

Matthias Jackisch presented work in progress. Using material gathered from the hospital during the week before the *Disorders* event, Jackisch transferred his studio to the hospital grounds. The starting point for Jackisch's work is his desire to work with whatever has been discarded by others at the site of the event. The pickings in this instance were rich. Hospital furniture, beds, bedside tables and bound copies of the *Lancet* created the visual framework for his outdoor performance *How to Draw*. Three surfaces were strewn with objects which would individually or collectively inspire the "drawing". On the first an umbrella, and a kinetic bauble attached to a large volume of bound medical magazines; on the second surface a ball of string and a plastic bubble; and on the third table a clay pot, a traditional sculpture, and several anatomical drawings from copies of the *Lancet*. Jackisch, alternately donning a philosopher's cloak and medical overalls, reinvigorated these discarded and previously sculpted items with a performative use derived from their original function. Becoming at once shaman, philosopher, doctor and artist, Jackisch brought together these worlds in a series of visual actions which were occasionally manic, then subdued and pensive, and at times hypnotic, but always drawing on the creative energies of each discipline.

Alastair Maclennan is best known for his durational performances and this event gave him the ability to demonstrate his commitment to this practice in an especially appropriate work. His was perhaps one of the most ambitious and physically demanding presentations. He maintained a waking presence in one of two sites in the hospital for the entire twenty-four hours. Changing locations on the hour every hour he performed alternately in the Central Hall of the South Wing and in the Old Pharmacy of the Lambeth Wing. In the Central Hall, a large tiled Victorian space housing a small collection of stone statues and a grand piano, Maclennan introduced a number of items. He arranged around the space many helium filled balloons (mostly black and a smaller number of white), two zimmer frames, black and white photographic negatives, twenty-five silver bowls, some remaining empty, and some containing water, leaves, marbles, a small metal rowing boat and a dismantled child's shoe. Maclennan moved slowly, almost imperceptibly, around this space, sometimes gently pushing a wheel chair decorated with white balloons. The only other action was the slow and barely visible deflation of the balloons. The atmosphere generated was intense yet calm, unnerving yet contemplative. Whilst the visual evidence confronting us was loaded with expectation and heavy with symbolism, the sombre character of the artefacts was transformed by the grace and serenity of the action itself. Out of the sinister and disturbing environment there came a possibility of spiritual renewal.

Only the wheelchair, a section of the child's shoe, and a smaller selection of balloons were installed in Maclennan's second space which was already filled with artefacts from its own history. The Old Pharmacy represents a small piece of hospital archaeology on display in the corner of a large waiting room. In front of the glazed screen, spectators were able to witness Maclennan's precise, meditative actions in this tiny space. Flasks, scales, phials, measuring jugs, storage jars and bottles were continually repositioned. On a formal level the space was constantly sculpted into new dimensions as each shelf or table was dismantled and reassembled elsewhere. But in the process of this action which was both careful and deliberate we contemplated the history and use of each item as its new display spot was allocated. Medicine has progressed far and fast in technological terms since the containers in this pharmacy were in daily use and yet the Maclennan additions to the space (the wheelchair, etc.) reminded us that the afflictions are just the same.

Alone amongst the artists contributing to this project Bruce Gilchrist was developing work that was close to its heart long before the invitation to participate arrived. In 1993 Gilchrist visited the sleep research laboratory at the University of Texas in Austin, USA and his project for *Disorders* is the result of ongoing research inspired by that visit. Gilchrist has been exploring ways in which dream states may be given tangible visibility with the use of computers and electroencephalograph (e.e.g.) machines. He is investigating the possibility of a communication conduit between the conscious and subconscious mind using codified electrical languages. Over the last two years Gilchrist has collaborated with practitioners from a variety of disciplines in order to pursue his research. *Art Emergent/Dissident States* is Gilchrist's first collaboration with a writer.

Alastair Maclennan
twenty-four hour performance
*Disorders*, Central Hall, St Thomas' Hospital
London, August 1996 (Photo: Nic Percy)          55

In a room off the South Wing Corridor Nick Rogers (the writer) sat wired up to an e.e.g. machine.

He was asked to think about the next section of his unwritten book. Whilst he was thinking his brain waves were analysed by the computer in the adjacent space, searching for matches with his previously recorded nascent thoughts and associated e.e.g. files. In this way the brainwave patterns triggered spoken text. The electronic speech was accompanied by graphic representations of the e.e.g. patterns which were projected onto the wall in the darkened space.[4]

Tiny snippets of text emerged, disappeared, were reconsidered and often emerged again. The writer's real time brain states were also driving a series of small vibrating electric motors embedded in a rubber jacket and shoes. Fluctuations in the e.e.g. pattern were represented by the ebb and flow of vibrations within the clothing. Members of the public were invited to wear this tactile clothing while listening to the stories and viewing the graphics. The tactile clothing represented an alternative sensual means of experiencing this work—adding the sense of touch (generated from the writer) to the sight and sound of his thoughts. Spectators were given unrestricted access to the analysis of the visual and aural sensations—they could come and go as they pleased and gather and interpret whatever evidence was being projected at the time. The third sensation

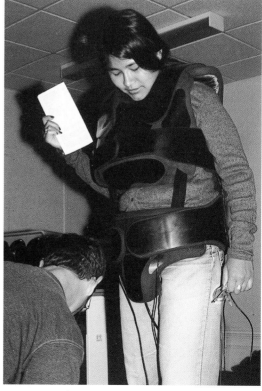

was more challenging in its presentation. The electronic mantel attached to several leads and wires, generated a nervousness in some spectators who felt uncertain about surrendering themselves to the restrictive clothing. They felt vulnerable and out of control strapped inside an object which had many associations with electric chairs and more violent instruments of torture. However, for those who willingly and often eagerly participated, and particularly for those who overcame their initial apprehensions, it was to witness the surrender to machinery that perhaps gave the project its real edge, especially given the medical context in which it was being viewed. It is the ability to make that leap of faith, for patients to put their trust in an electronic process with which they are unfamiliar, which is a necessary part of medical testing and which can, if carefully developed, ultimately lead to new understandings of treatment. Gilchrist and his collaborators (and to a lesser extent the more intrepid members of his audience) make equivalent strides into the unknown in order to heighten our perceptions of it.

Sonja Zelic's project also involved audience participation, but of a different kind. This work was originally conceived as a response to migration and the artist subsequently developed and extended it for its new context. There were three elements to *Sleep Walking* which was situated at a little distance from the Gilchrist piece along the South Wing Corridor. The participatory element in the work involved 240 Polaroid images taken from the same spot over the twenty-four hour period. The camera was positioned to point at people's feet in order to make the act as unthreatening as possible. Ten shots (one Polaroid film) were taken each hour (approximately one photograph every five minutes). Each image was displayed on the wall behind the camera recording the exact time at which it was taken.

> The act of taking the photos was also a form of counting, of marking time—the Polaroids could be put up as an immediate record of this . . . . The photos created much interest and discussion between myself, patients and staff at the hospital (doctors, porters, tea ladies) with many trying to decipher if the legs I had caught en route belonged to them . . . I switched off the automatic functions on the camera so that there was no adjustment to movement or lack of light, therefore many of the images look blurred or fragmented . . . . As the camera cannot grasp the image without all its automatic functions—in some respects it is in a mode of unconsciousness while the picture is being taken—equivalent to the images and thoughts which occur just before going to sleep, during sleep or after a period of sleep deprivation.[5]

Next to the display of the Polaroid images, projected through a window from outside the building, was a 16 mm black and white film of white geese walking slowly in one direction then turning and walking slowly in the opposite direction. This film ran continuously on a 4 minute loop. On the wall at right angles to the film projection was a goose down quilt framed in perspex. As it grew dark, the film projection became more visible and was reflected in the perspex frame creating the illusion that the geese were walking into and out of the quilt. Each element in this work addresses the time between consciousness and unconsciousness, between wakefulness and sleep.

Bruce Gilchrist with Nick Rogers
*Art Emergent/Dissident States* a collaboration between artist and writer using an e.e.g machine, computers, projected text and activated clothing in a continuous live event, *Disorders* St Thomas' Hospital, London, August 1996 (Photos: Nic Percy)

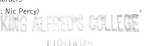

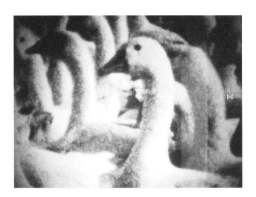

Sonia Zelic
*Sleep Walking* (all images)
16mm film loop, Polaroid photos, goosedown quilt
*Disorders*, St Thomas' Hospital, London, August 1996
(Photos: Nic Percy and Jon Byers)

The response by the hospital to this project has been reflected in a number of ways, but most particularly by the fact that the Trustees have purchased Zelic's work *Sleep Walking* for permanent display in the new Sleep Research Centre. As part of the programme Paul Burwell was commissioned to present a pyrotechnic event for the actual opening of the Sleep Centre two months later. Even though they had initially turned down Beaconsfield's proposals, the hospital were pleased with the amount of publicity and visitors that the *Disorders* project generated. For the Trustees it was a risk they had not undertaken before. Although they have a substantial collection of paintings and prints they had never commissioned a live event. Whilst there was some nervousness from the hospital in advance of the more controversial aspects of the day, the Clinical Operations Manager maintained his commitment to the overall programme and gave the necessary authority for the project to develop. The greatest credit for the artistic success of this enormously ambitious event must nevertheless rest with Beaconsfield who maintained a focussed and visionary curatorial position throughout, no doubt inspired by the thinking reflected in the quotation from the programme.

> . . . Obviously in a cultural climate where radical autonomy has been the built in assumption of artistic practice for so long, to propose a shift in the artists' role from that of self-directed, achievement oriented professional to something like that of a cultural awakener or healer is to open oneself up to the accusation of mistaking art for a medical emergency team trying to save Western culture from itself . . . [6]

Each of the thirteen contributions, heavily imbued with the hospital surrounding and inspired by its context, would have been equally successful if removed from the *Disorders* programme and viewed with commensurate impact elsewhere. The work would lose that especially loaded atmosphere that the hospital undoubtedly placed upon it but each artist would create a new framework for its viewing, wrenching another position for each piece and building layers upon what originally existed in the medical context. For those who were unable to witness the events on that day it is possible that a film documentation of the twenty-four hours will at some point be completed. But it is unlikely that a film will be able to capture the particular experience which attending the event itself offered and which in many ways could be described as a parallel process to Hobson's description of REM sleep—"The brain and its mind seem to be engaging in a process of fantastic creation. It is obvious that our dreams are not simply the reliving of previous experience. On the contrary, we are often fabricating wholly novel ones. Thus new ideas and new feelings, and new views of old problems, can be expected to arise within dreams".[7]

# Notes

1.  Gablik, Suzi, *The Reenchantment of Art*, London: Thames and Hudson, 1991, pp. 41-58.

2.  Extract from Rona Lee's text in the *Disorders* programme.

3.  Watson, Gray, "Precarious Balances: Fuel for Speculations" in *Rona Lee*, Colchester: Firstsite, 1996, pp. 55-60.

4.  Extract from Bruce Gilchrist's text in the *Disorders* programme.

5.  Taken from notes by the artist, some of which were used to accompany the permanent siting of the Polaroid work *Sleep Walking* in the new Sleep Research Centre.

6.  Gablik, Suzi, *The Reenchantment of Art*, London: Thames and Hudson, 1991, pp. 41-58.

7.  Hobson, J. Allan, *The Dreaming Brain*, London: Penguin, 1990.

## Acknowledgments

I would like to thank John Kieffer and Paula Brown at London Arts Board for
identifying the need for this book and giving me the opportunity to write it.
I am particularly grateful to Naomi Siderfin, Bruce Gilchrist, Peter Hatton
and Val Murray for all the time and material they have given during the research
period. Thanks also to Lois Keidan, Jonny Bradley, Peter Harper, Nick Rogers
and Rachel Armstrong for their helpful and generous contributions.
Thanks to Axel, Eve, May and Dora for their forbearance and to Cecilia Sjoo
for picking up the pieces. Thanks especially to Duncan McCorquodale for guiding
the project to completion.

**Colophon**

© 1997 Black Dog Publishing Limited, the author and artists.
Produced by Duncan McCorquodale.
Designed by CHK Design Limited, London.
Printed in the European Union by Graphite Inc. Limited.

All opinions expressed in material contained within this publication are those
of the authors and artists and not necessarily those of the editors or publishers.

British Library Cataloguing-in-Publication Data. A catalogue record for this book is
available from The British Library. Library of Congress Cataloguing-in-Publication
Data: *Low Tide — Writings on Artists' Collaborations*.

ISBN 1 901033 85 6

Cover
**TEA/IT**, Museum Installation, *Other People's Shoes*
Leeds Metropolitan University Gallery, 1994
(Photo: Paul Grundy)